Moonstone Press

Project Editor: Stephanie Maze
Art Director: Alexandra Littlehales
Senior Editor: Rebecca Barns

PHOTOGRAPHY: Front cover: © 2002 Nicole Duplaix/National Geographic Image Collection;
Back cover: © 2002 Paul & Shirley Berquist/Animals Animals; © 2002 John & Karen
Hollingsworth/Courtesy of U.S. Fish and Wildlife Service; © 2002 Steven J. Krasemann/DRK
Photo; © 2002 Johnny Johnson/DRK Photo; © 2002 O.S.F./Animals Animals; © 2002 Robert I.
Campbell/National Geographic Image Collection; © 2002 Tui de Roy/Minden Pictures; © 2002 Joel
Sartore; © 2002 Stan Osolinsky/Corbis Stock Market; © 2002 Jim Brandenburg/Minden Pictures;
© 2002 Fred Bavendam/Minden Pictures; © 2002 Photowood Inc./Corbis Stock Market;
© 2002 Mitsuaki Iwago/Minden Pictures; © 2002 Michael Fogden/DRK Photo;
© 2002 Ron Sanford/Corbis Stock Market; © 2002 Michio Hoshino/Minden Pictures.

Published in the United States by Moonstone Press,
7820 Oracle Place, Potomac, Maryland 20854

ISBN 0-9707768-1-0
Library of Congress Cataloging-in-Publication Data
Maze, Stephanie.
Peaceful moments in the wild : animals and their homes / Stephanie Maze.—1st ed.
p. cm.—(Moments in the wild ; 2)
Summary: Photographs and simple text present a variety of animals in the places where they live.
1. Animals—Habitation—Juvenile literature. [1. Animals—Habitations.] I. Title. II. Series
QL756 .M33 2001
591.56'4—dc21 2001045289

First edition
10 9 8 7 6 5 4 3 2 1

Printed in Singapore

Peaceful Moments
In the Wild

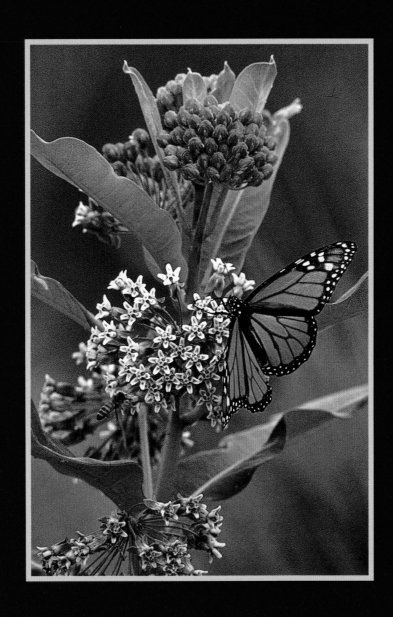

Animals and Their Homes

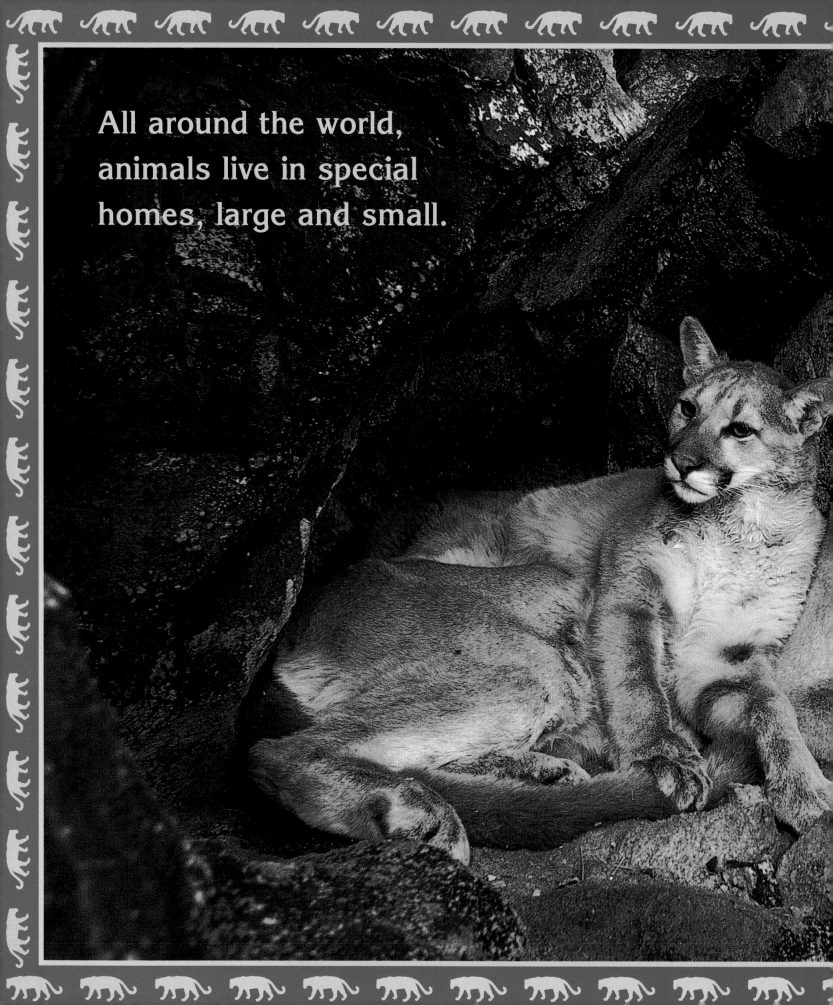

All around the world,
animals live in special
homes, large and small.

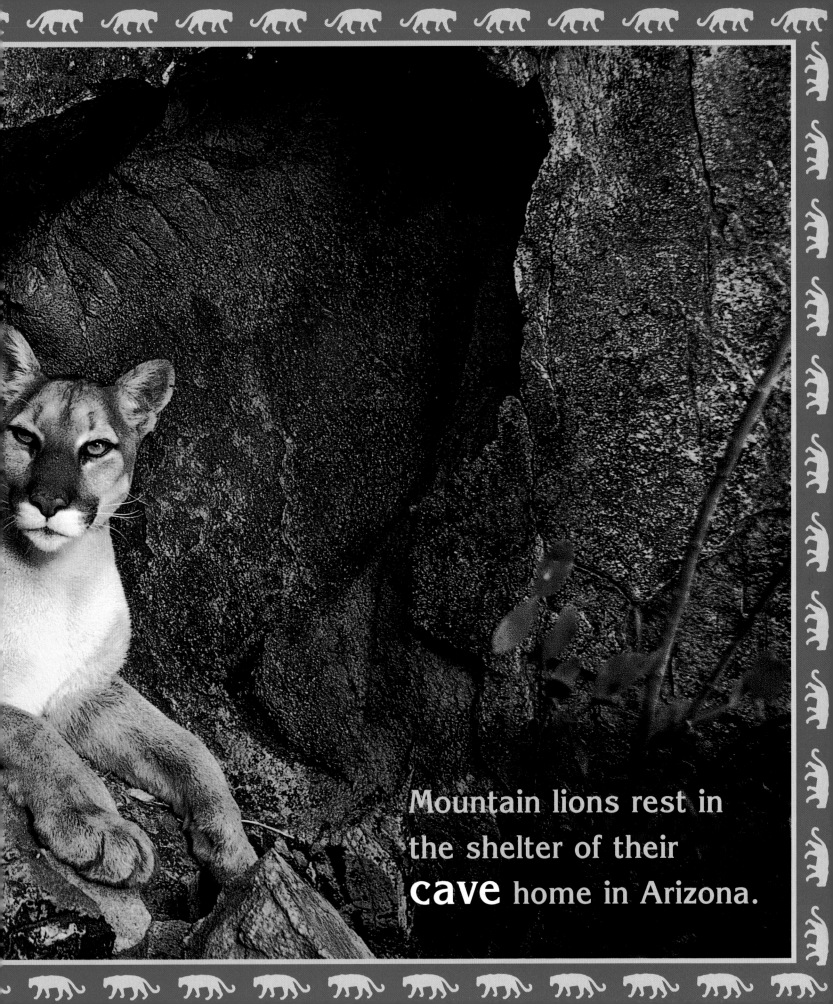

Mountain lions rest in the shelter of their **cave** home in Arizona.

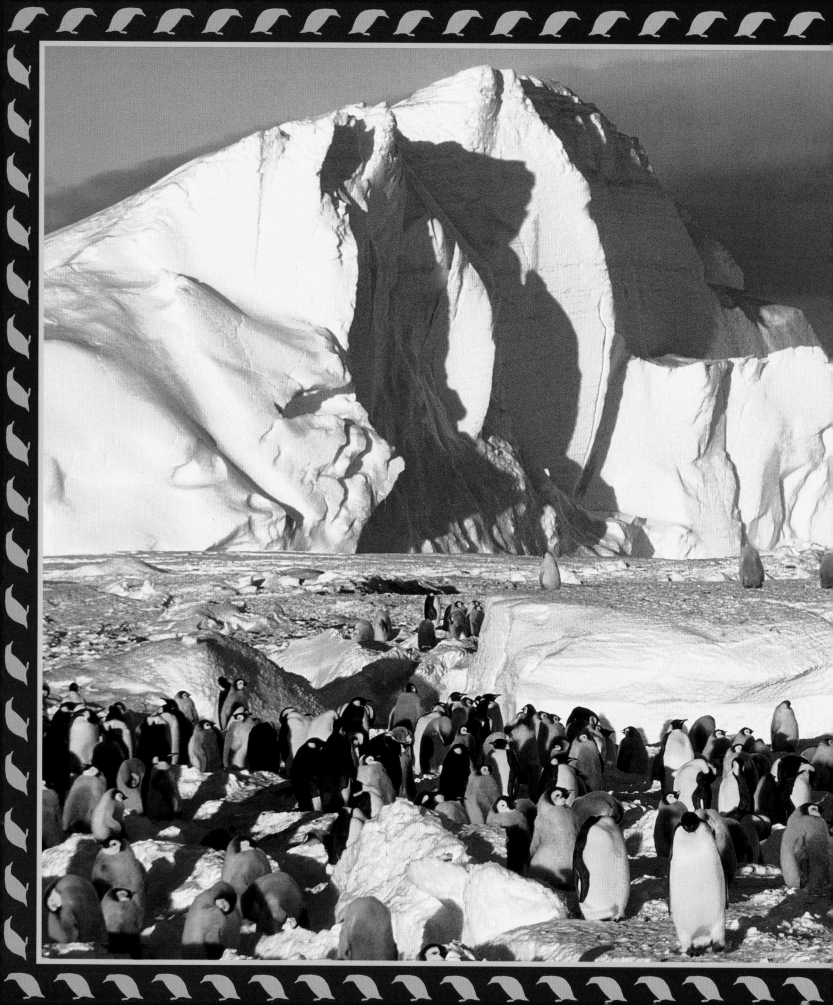

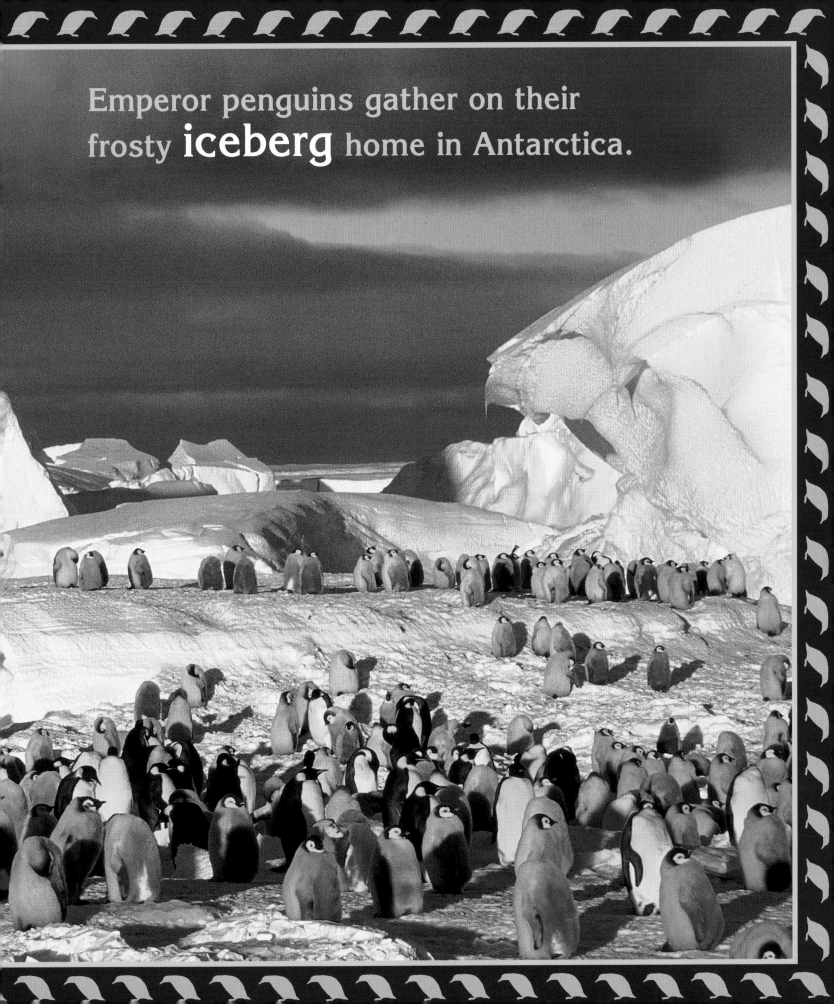

Emperor penguins gather on their frosty **iceberg** home in Antarctica.

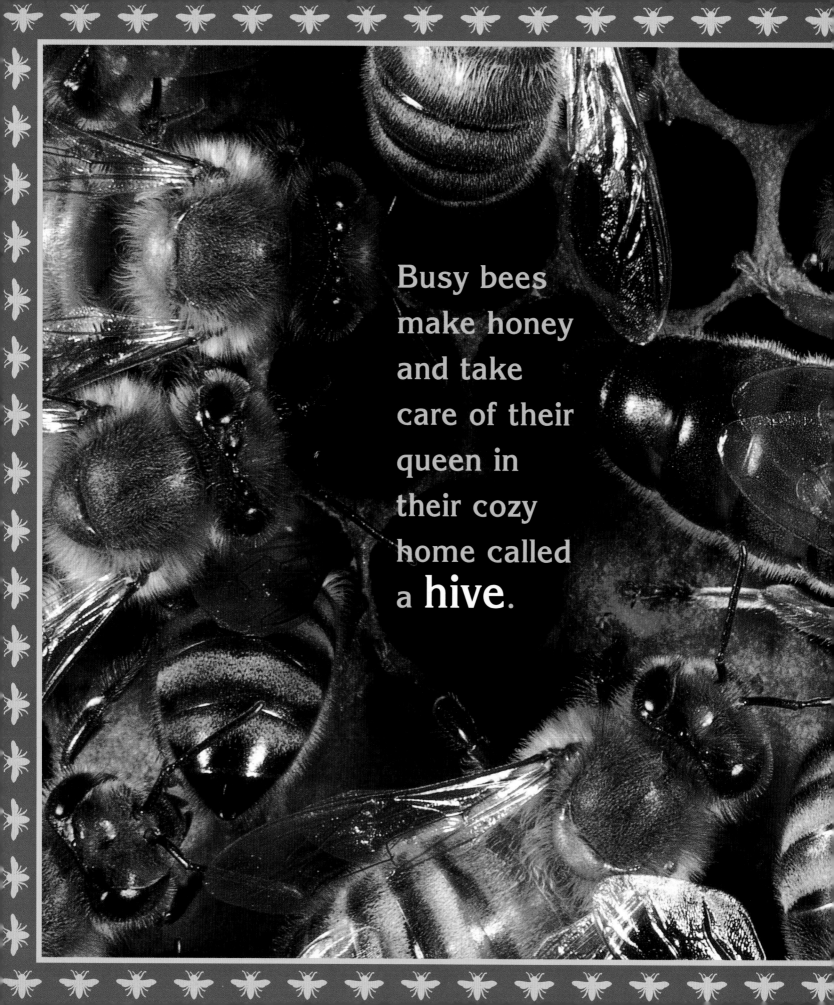

Busy bees make honey and take care of their queen in their cozy home called a **hive**.

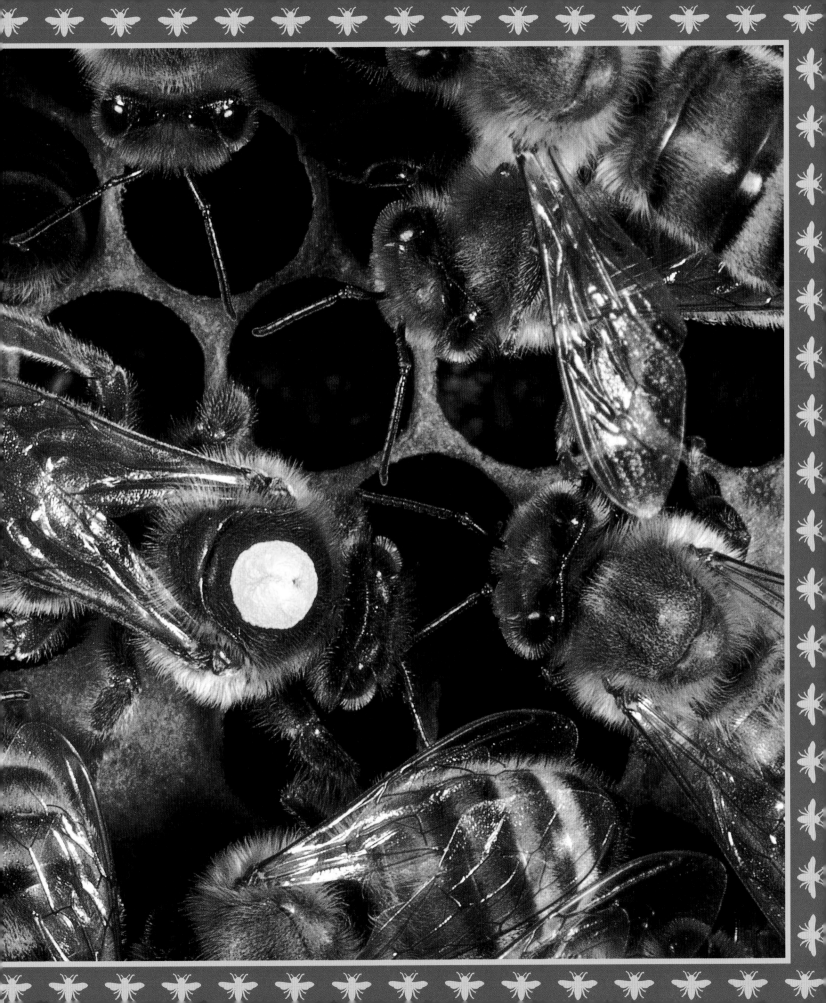

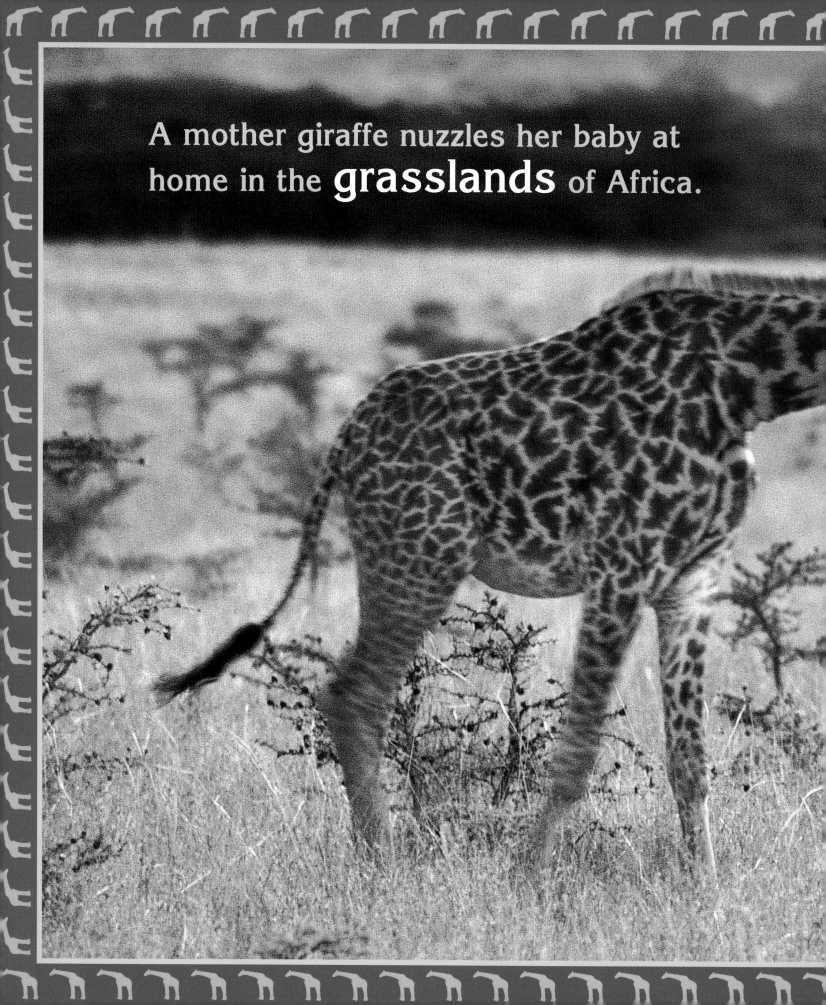

A mother giraffe nuzzles her baby at home in the **grasslands** of Africa.

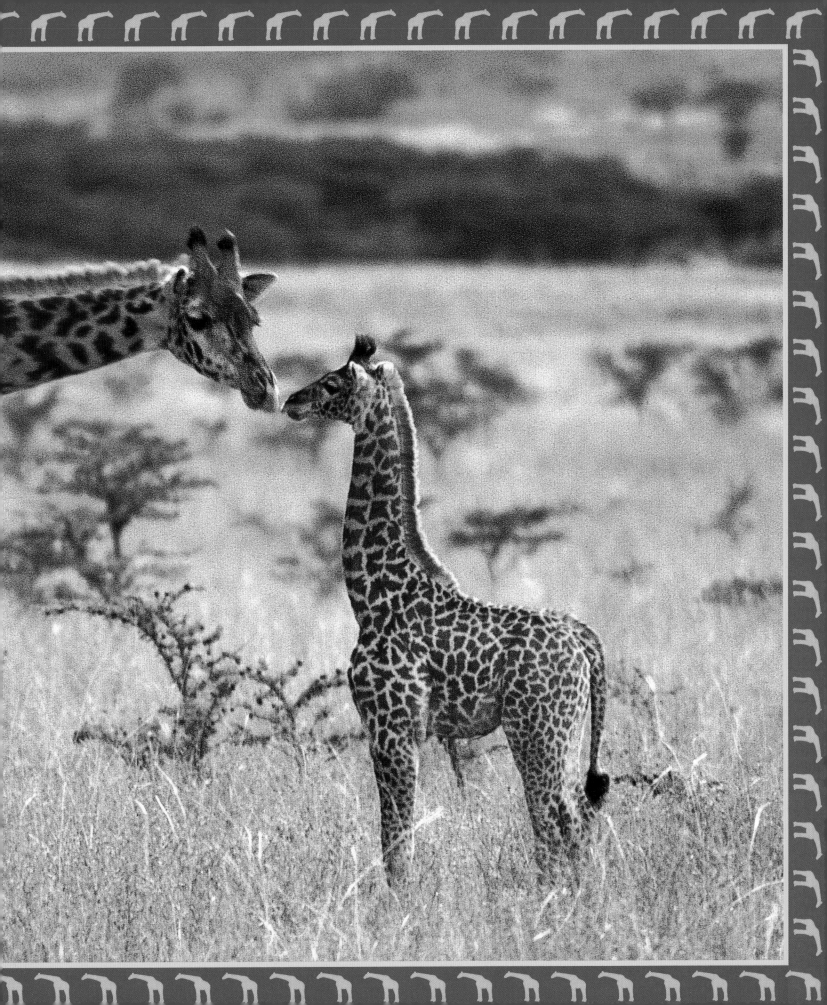

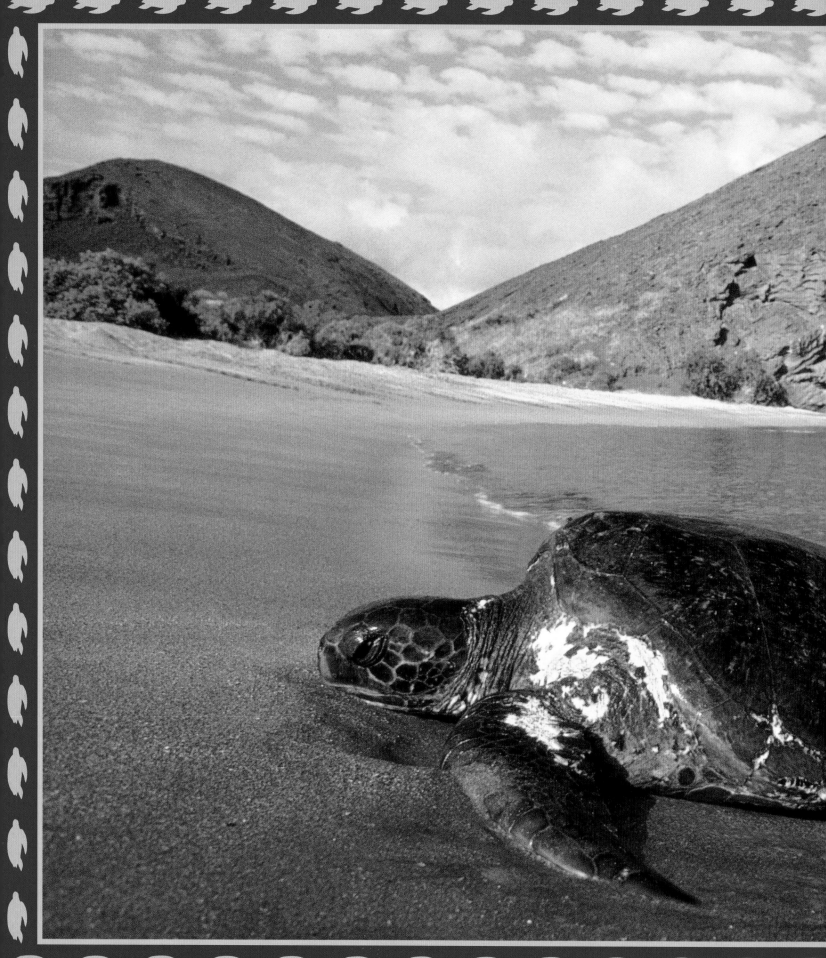

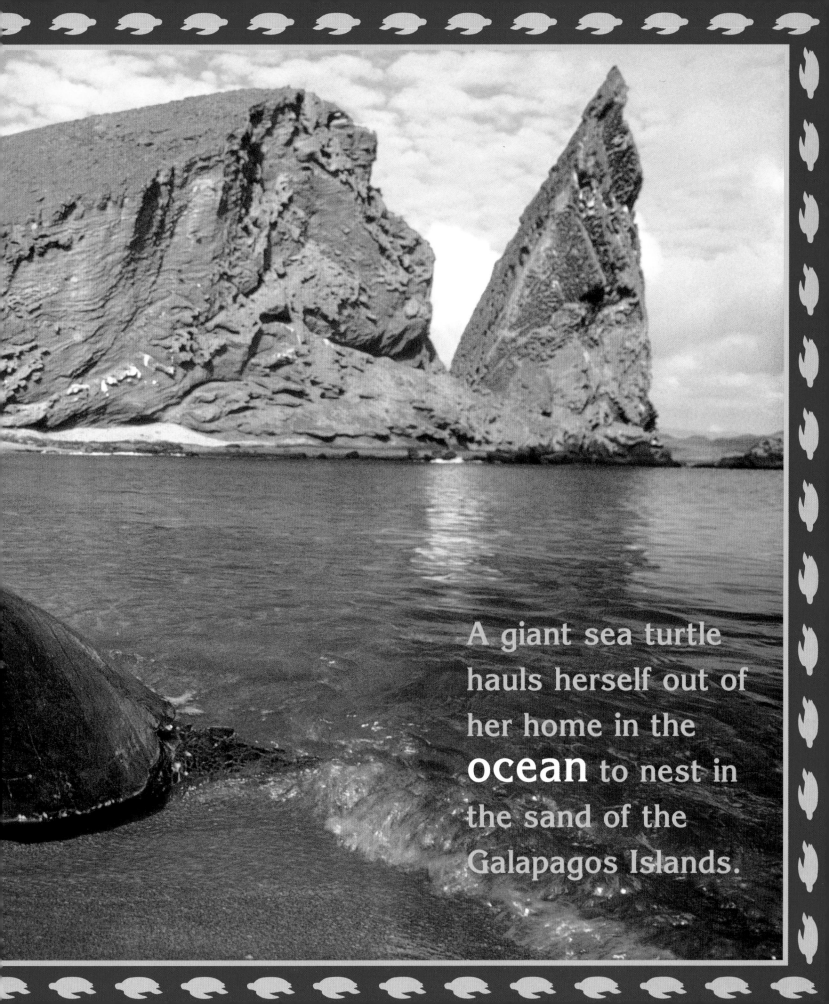

A giant sea turtle hauls herself out of her home in the **ocean** to nest in the sand of the Galapagos Islands.

A rattlesnake shakes its noisy tail to warn intruders to stay out of its **desert** home.

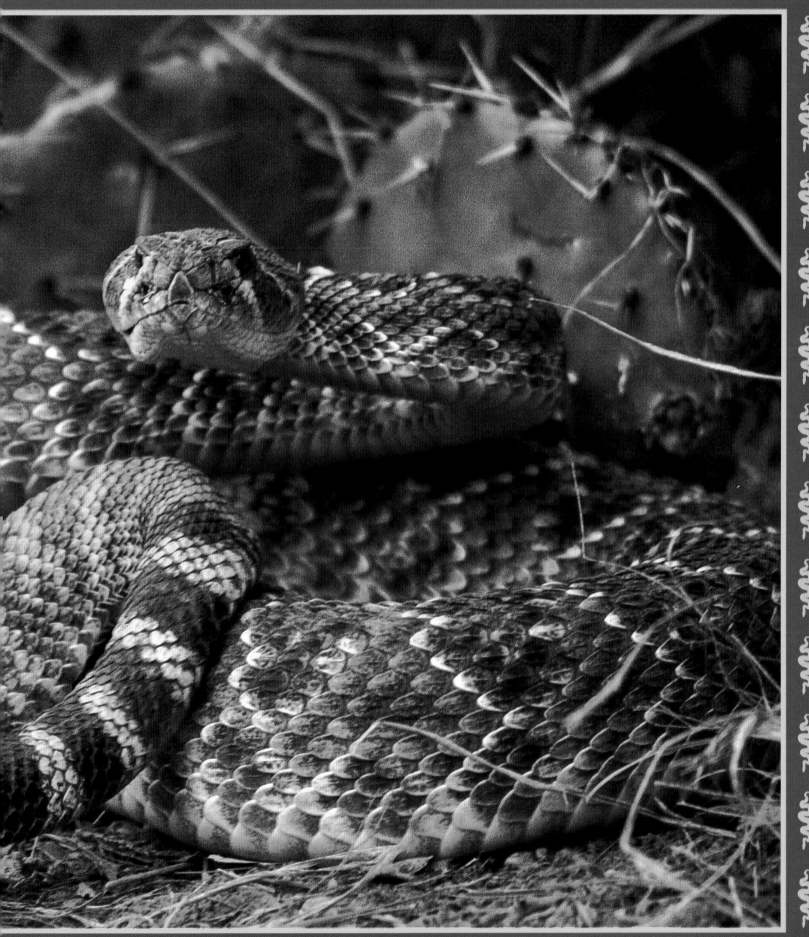

A great egret sneaks up on a fish in its **swamp** home in the Florida Everglades.

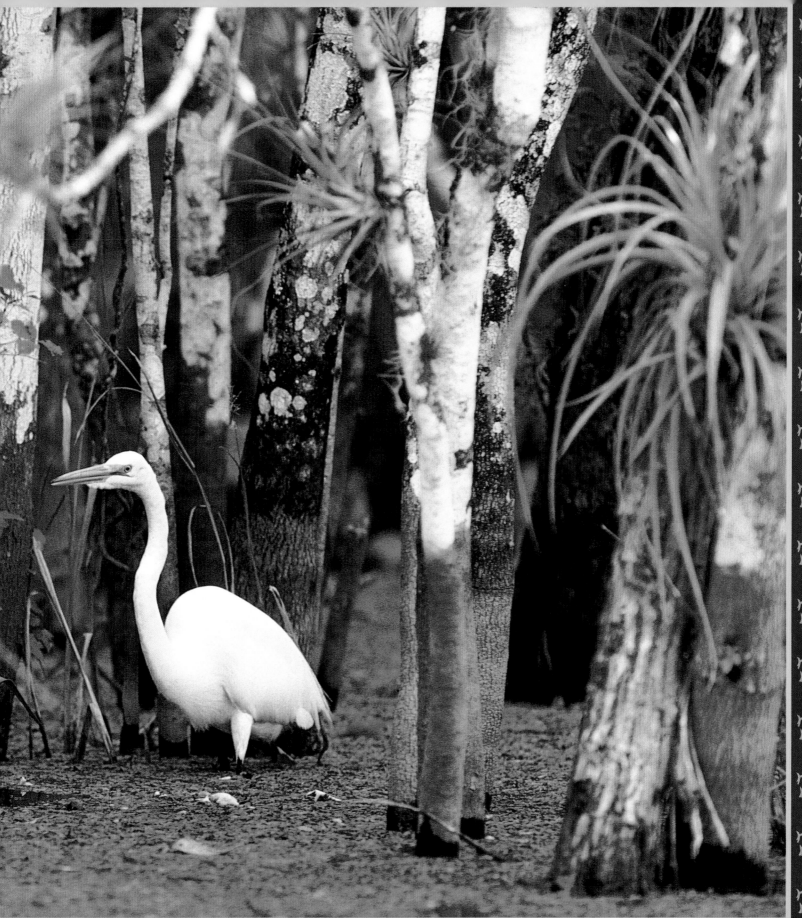

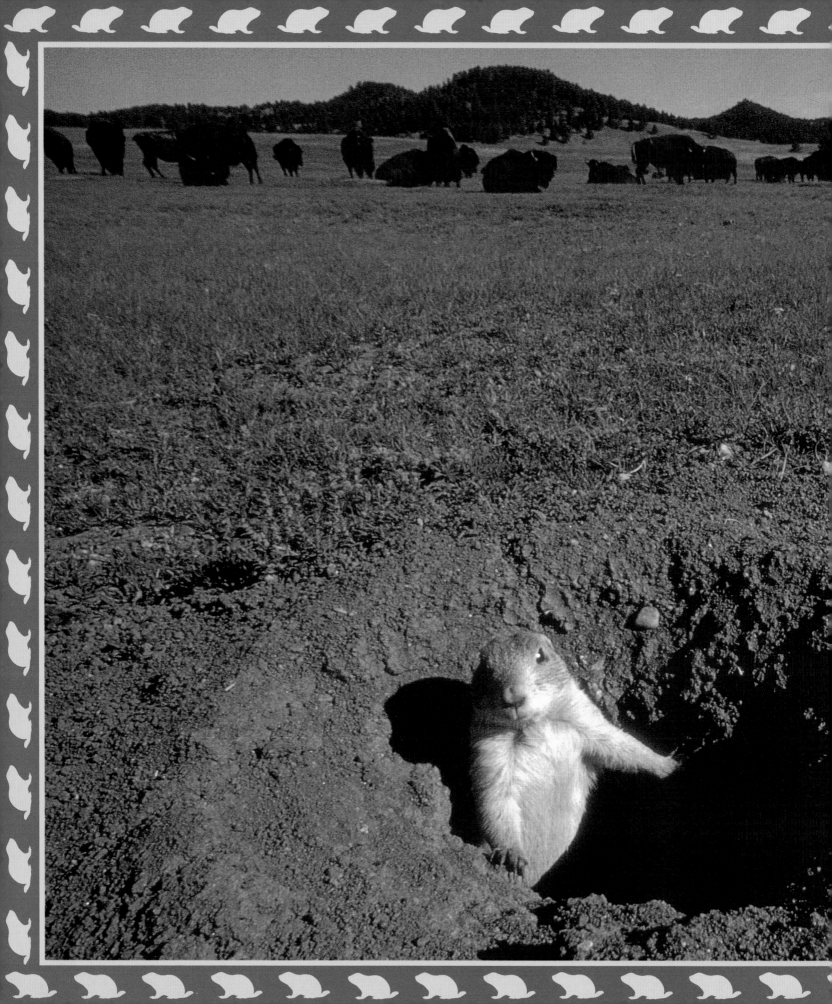

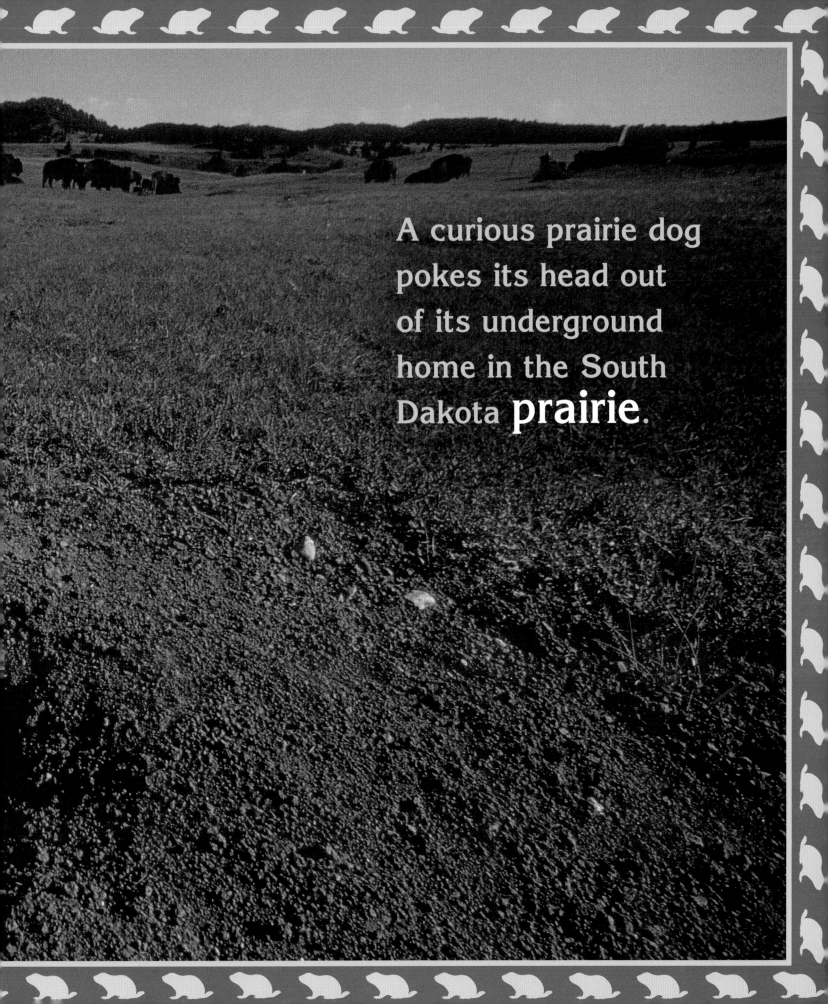

A curious prairie dog
pokes its head out
of its underground
home in the South
Dakota **prairie**.

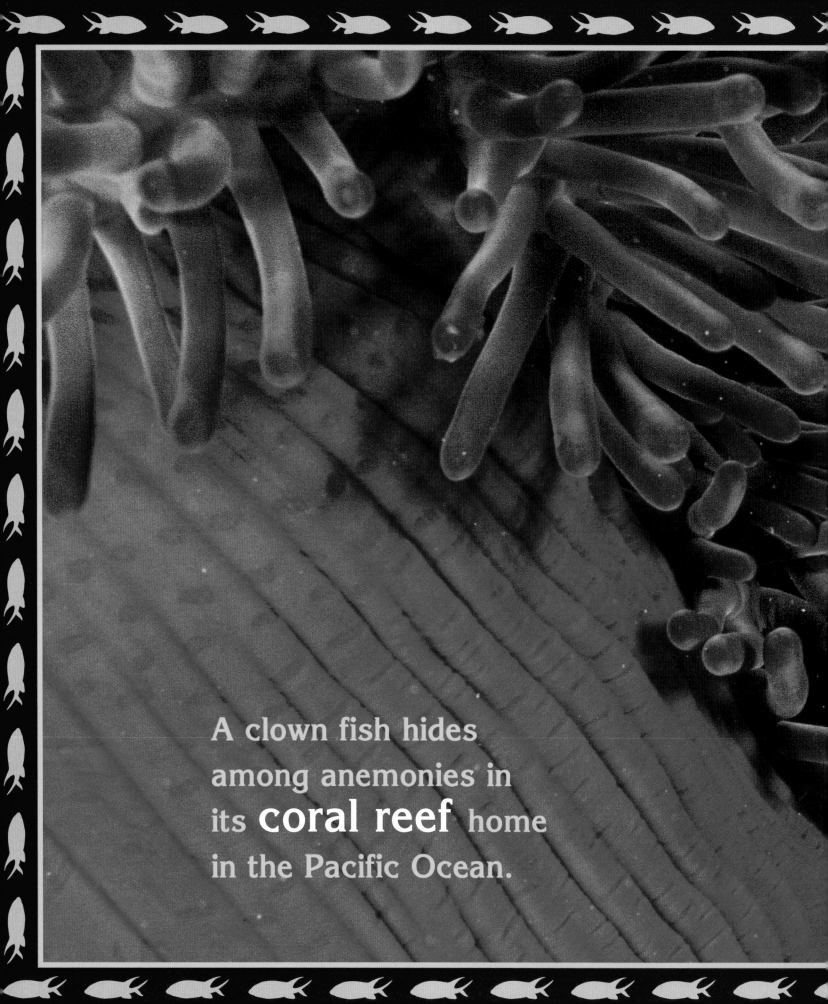

A clown fish hides
among anemonies in
its **coral reef** home
in the Pacific Ocean.

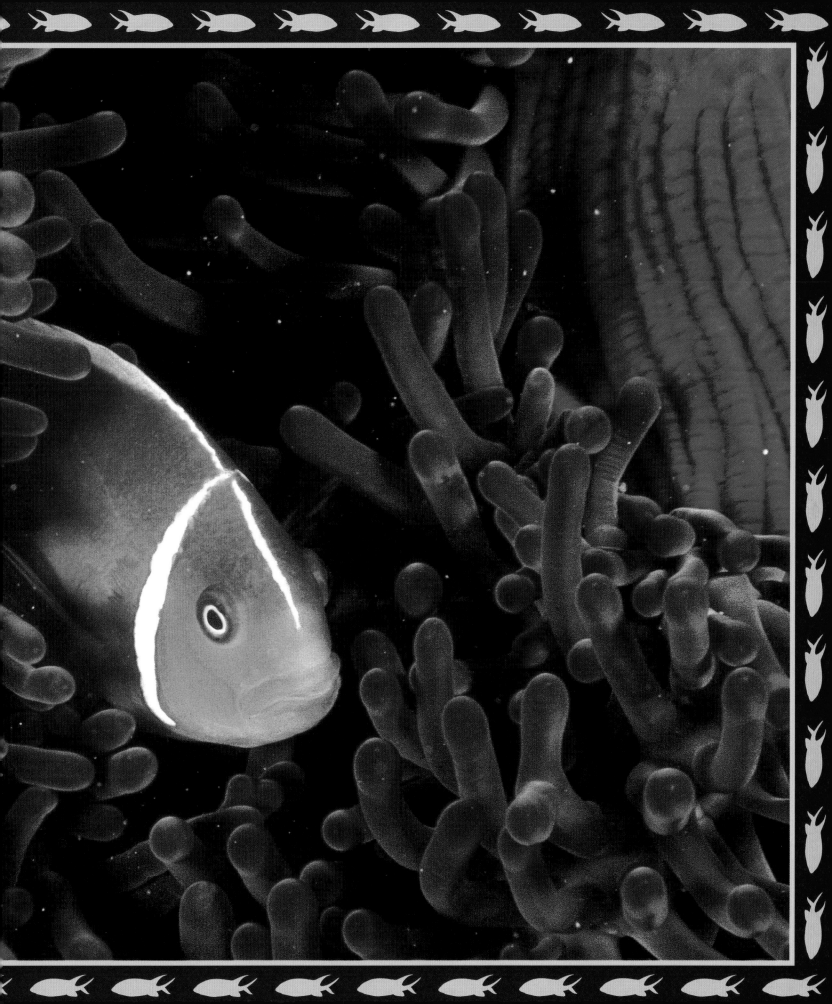

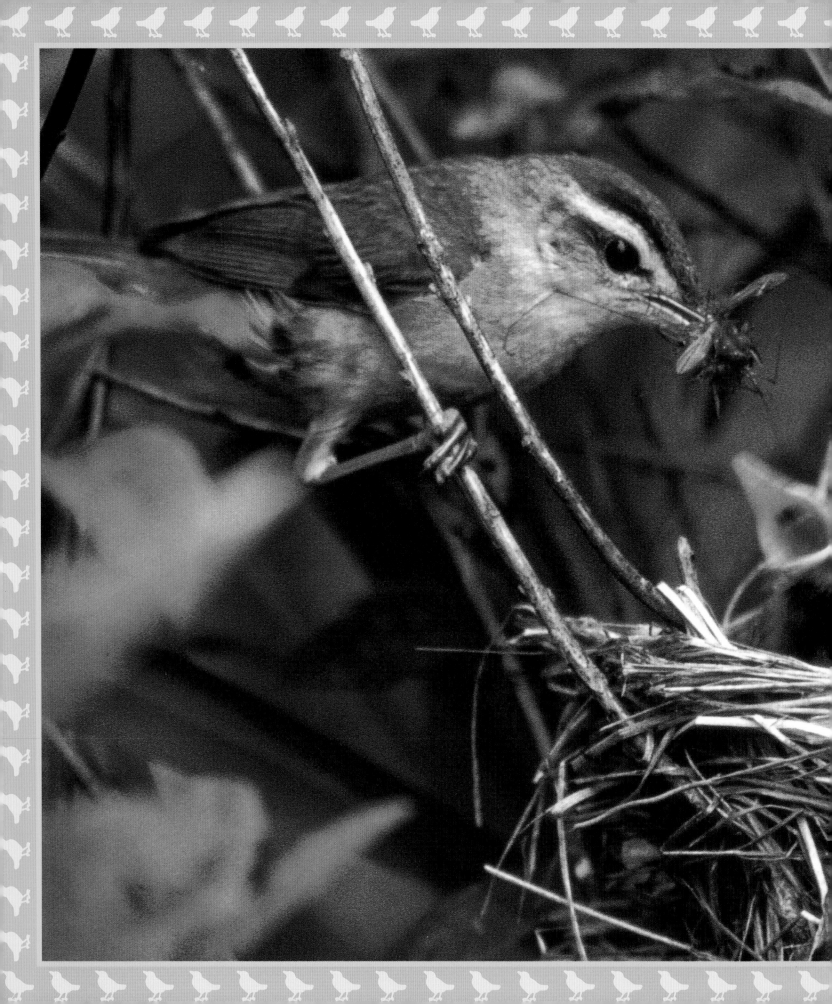

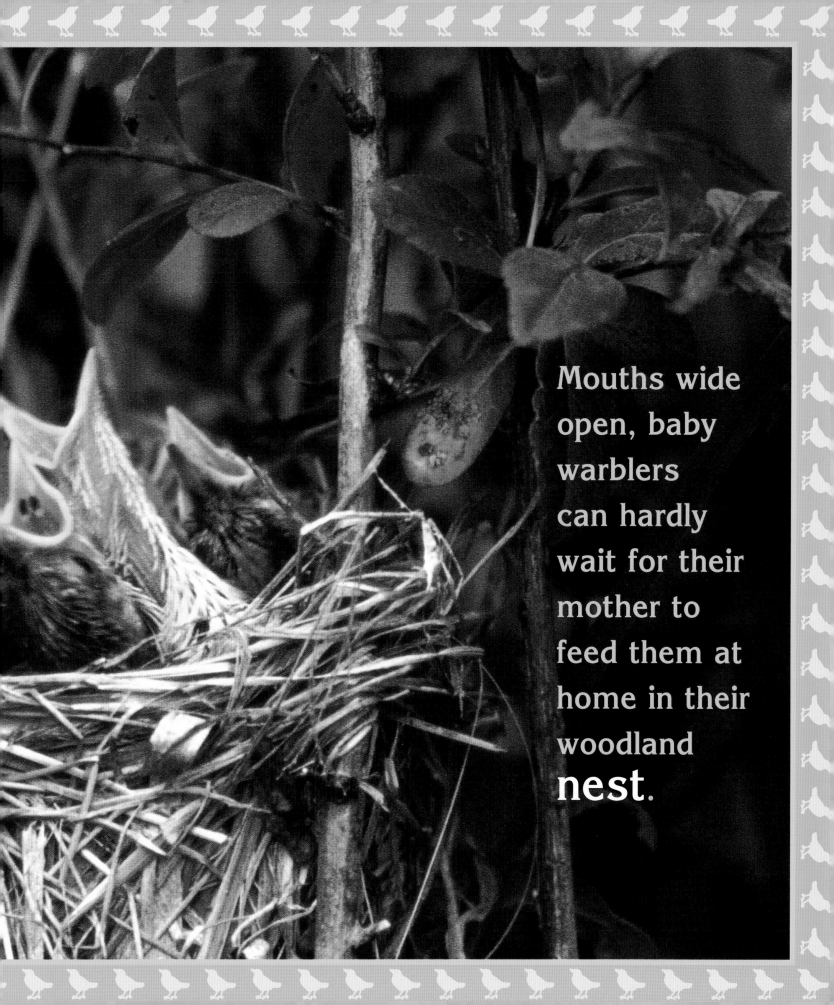

Mouths wide open, baby warblers can hardly wait for their mother to feed them at home in their woodland **nest**.

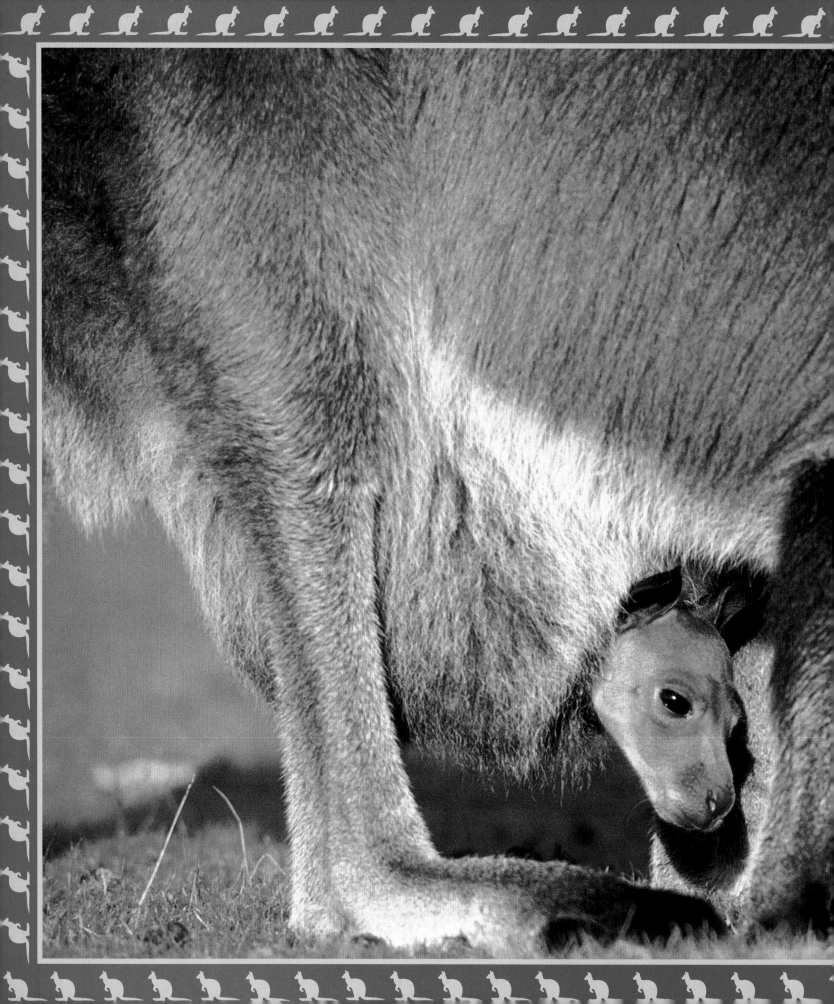

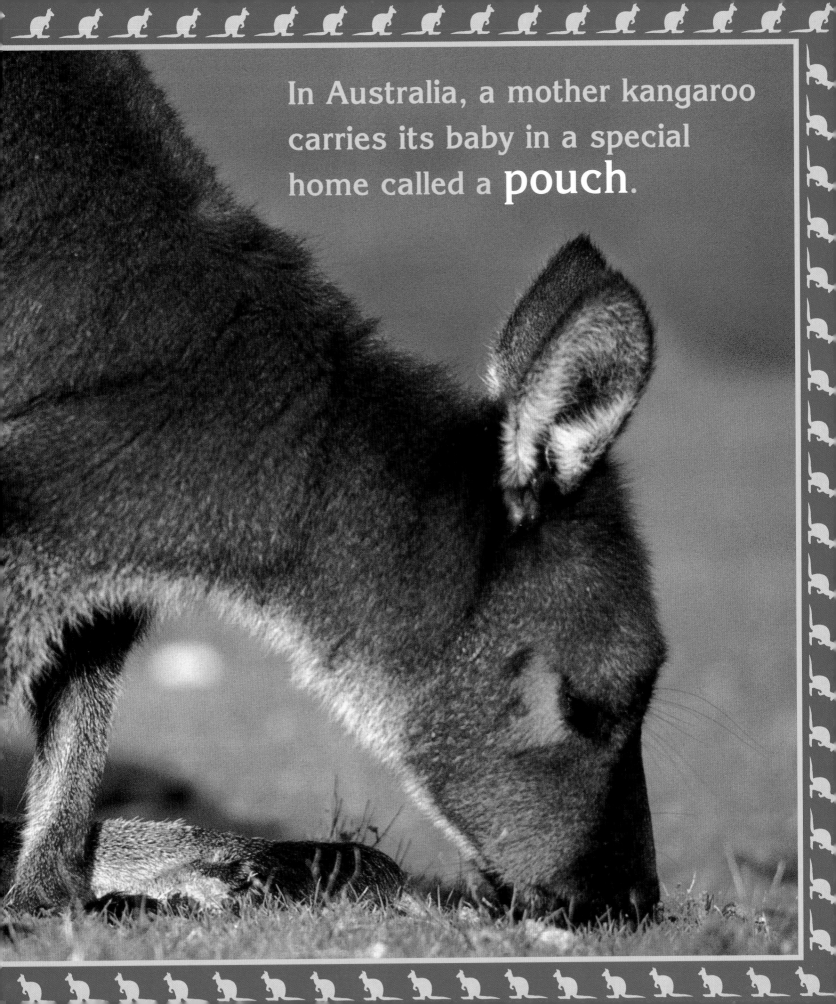

In Australia, a mother kangaroo carries its baby in a special home called a **pouch**.

A lizard clings to a fallen branch in its **rainforest** home in Costa Rica.

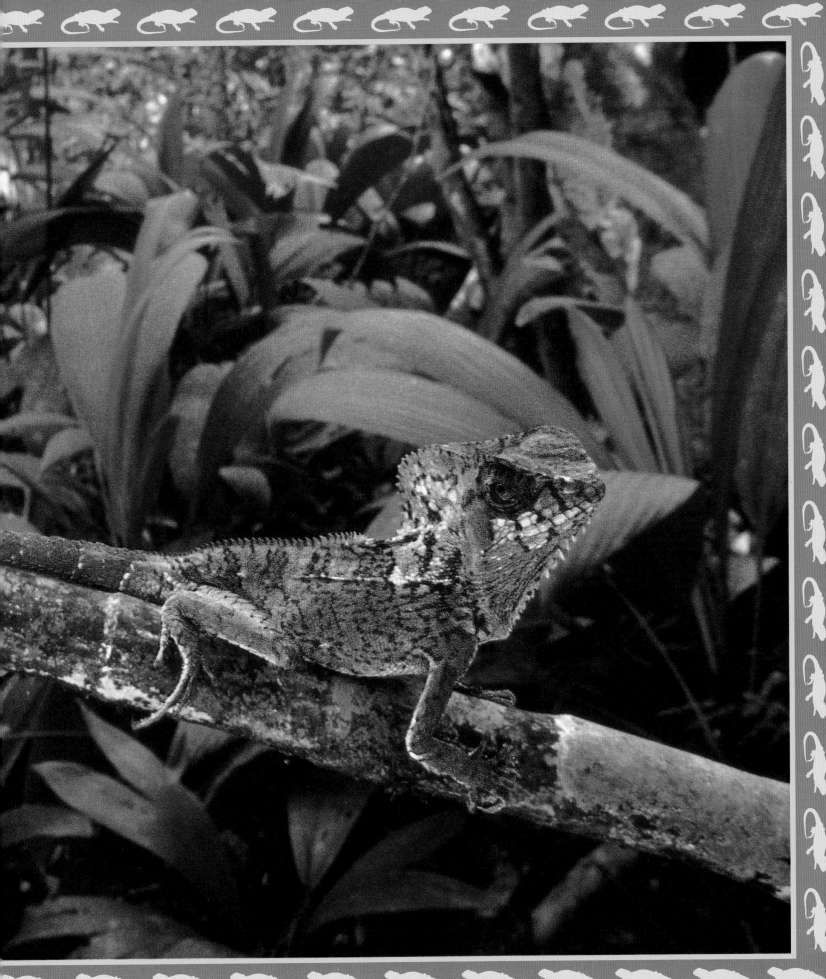

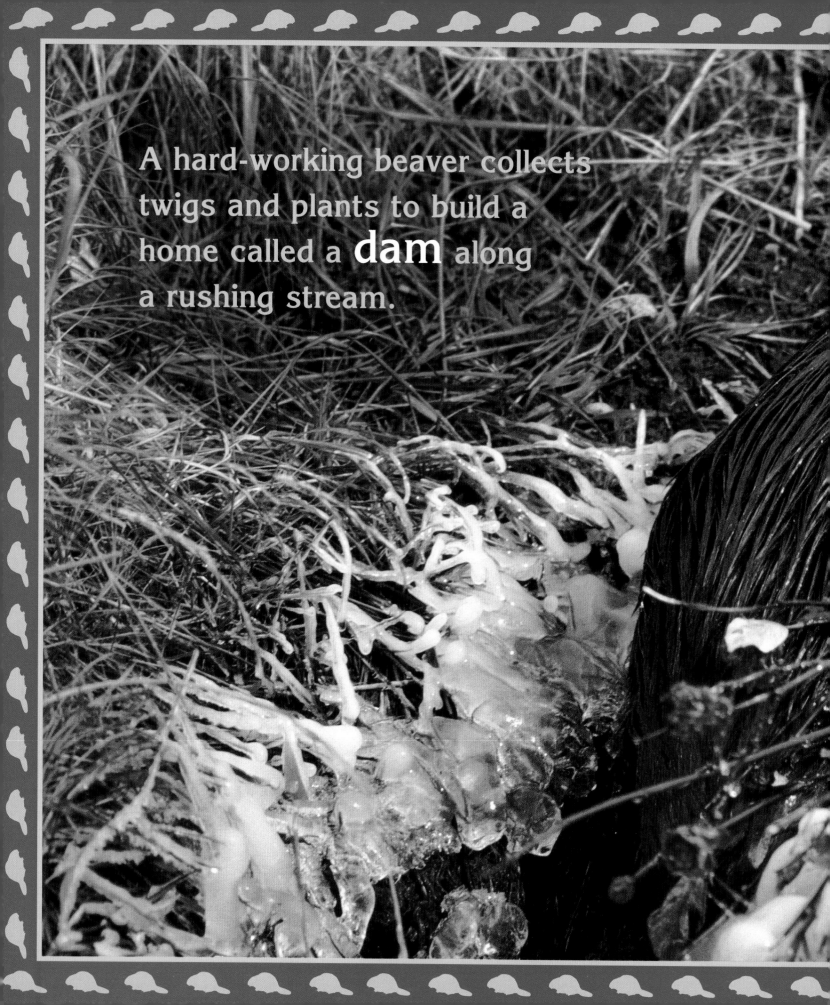

A hard-working beaver collects twigs and plants to build a home called a **dam** along a rushing stream.

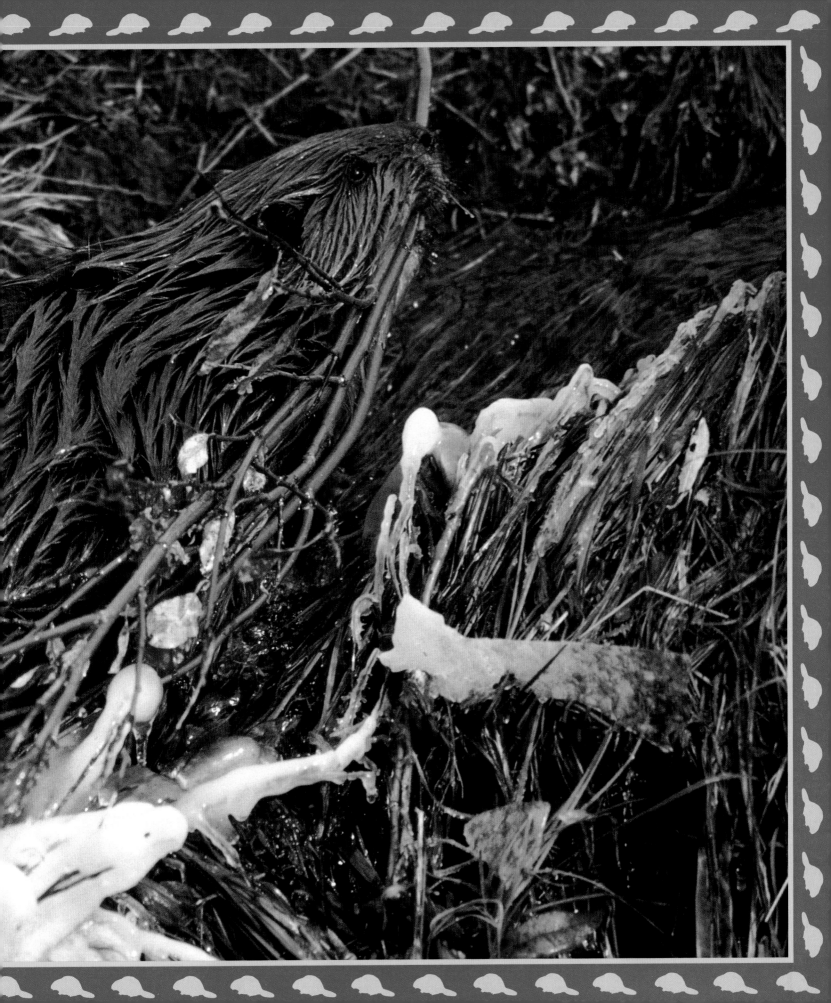

Dall sheep rest high in their **mountain** home in Alaska.

All around the world, animals live in their own special homes—just like humans do.